Jon Van Zyle's
IDITAROD MEMORIES

25 YEARS OF POSTER ART FROM THE LAST GREAT RACE

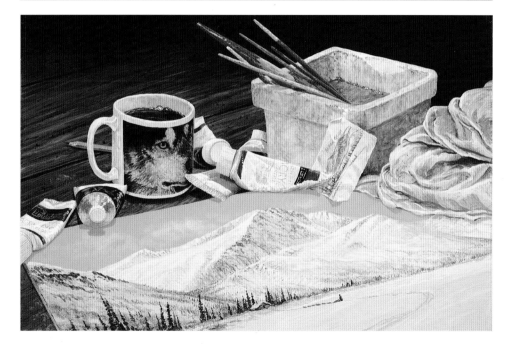

STORIES BY JONA VAN ZYLE

EPICENTER PRESS

Epicenter Press is a regional press founded in Alaska whose interests include but are not limited to the arts, history, nature, and diverse cultures and lifestyles of the North Pacific and high latitudes. Epicenter seeks both the traditional and innovative in publishing high-quality nonfiction books and contemporary art and photography gift books.

Publisher: Kent Sturgis
Editor: Marcia Woodard
Design: Elizabeth Watson/Jon Van Zyle
Proofreader: Sherrill Carlson
Printer: C&C Offset Printing Co., Ltd.

To order extra copies of JON VAN ZYLE'S IDITAROD MEMORIES, visit www.EpicenterPress.com or mail $16.95 plus $4.95 (shipping/handling) to Epicenter Press, Box 82368, Kenmore, WA 98028. Washington residents add $1.47 for state sales tax. You also may fax your order to (425) 481-8253 or phone it toll-free to (800) 950-6663. Visa, MC accepted.

Booksellers: Retail discounts are available from our trade distributor, Graphic Arts Center Publishing, Box 10306, Portland, OR 97210.

Original paintings, prints, and posters from Jon Van Zyle may be purchased at EpicenterPress.com.

First printing October 2000
10 9 8 7 6 5 4 3 2

PRINTED IN HONG KONG

Contents

This book is dedicated to our dogs, who not only take us where we want to go but also brought us together.

Foreword

The very word "Iditarod" makes my spine tingle and causes cold chills to course through my body. The Iditarod conjures up images demonstrating the spirit, competition, determination, isolation, endurance, ingenuity, and perseverance of sled dogs and their masters. Like no other contest on earth, it tests the mettle of man and beast.

Words seem so inadequate when it comes to conveying the totality of the Iditarod experience to those who've never lived it. It is here that we turn to art in an effort to communicate more completely. Art can make us feel sixty-five degrees below zero and see a moon that fills the sky during a lonely night on the trail 200 miles from civilization.

Through his creation of annual Iditarod posters for the past twenty-five years, Jon Van Zyle has brought us as close to running the Iditarod as a person can get without owning a dog team. In the beginning, the posters were an important source of revenue for the financially strapped dog race, and they remain a valuable fundraiser today. Their continuity over two and a half decades gives us an astonishing view of just what the race has meant to Jon Van Zyle — an Alaskan, a dog lover, musher, and Iditarod enthusiast from the very beginning.

My wife and I have enjoyed Jon's collection of Iditarod art for years. While visiting Jon at his Eagle River home, we've listened spellbound as he told stories associated with the posters' subject matter. It's exciting to see all the art and stories in one volume, available to everyone! I commend it to you.

— Fuller A. Cowell

Introduction

The Iditarod is more than a sled dog race: it's a thousand-mile journey, a challenge, an Alaska adventure, and a life-changing event. Jon Van Zyle was so moved by his 1976 Iditarod experience that he felt the need to capture and record his race impressions. Some men, like Robert Service, have the gift of words to share their experiences. Jon's gift is his ability to paint his stories and, through his alpenglow pinks and blizzardly blues, he invites us to travel along with him.

Jon completed his first race in twenty-six days, eight hours, forty-two minutes, and forty-two seconds. By the fall of 1976, he had translated many of his race memories into twenty acrylic paintings and debuted them in a one-man show at The Gallery in Anchorage; most of the paintings sold immediately. The interest in his Iditarod images prompted Jon to suggest to friends Walt and Gail Phillips, then acting treasurer and secretary of the Iditarod Trail committee, that producing a poster might be a helpful fundraiser for the fledgling race. Dorothy Page, committee chair, and the balance of the Iditarod committee agreed, but they had no money available to help finance the project.

Going out on a limb, Jon secured a personal loan, financed the first posters, and printed a limited edition of 2,500. In 1977 there were few rules or set protocol for reproduction art; the art print industry was just starting, and no one realized how successful it would become in future years. In fact, Jon decided to remove the date from the first poster because he thought it could be used for many years.

At this point he wasn't planning on doing a series of posters, let alone starting a tradition.

The first poster signing was held in March of 1977 and was an immediate success thanks in part to an article in the *Anchorage Daily News*. Fifteen hundred of the first posters carried Jon's printed name but were not personally autographed; they sold for five dollars each. One thousand of the posters were autographed and numbered; they sold for ten dollars. Approximately 100 were also "signed" by one of Jon's favorite leaders, Pikaki. Posters containing her inked paw print are considered a special find by avid collectors.

In the early years, the race received minimal media coverage. The importance of the first poster was its success as a large-scale marketing item for the Iditarod; it opened the door for future fundraising products and it brought attention to

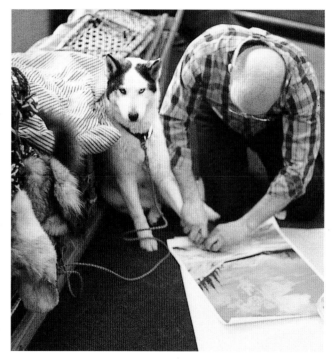

Pikaki has had just about enough of this autographing . . . but the line of people still keeps coming!

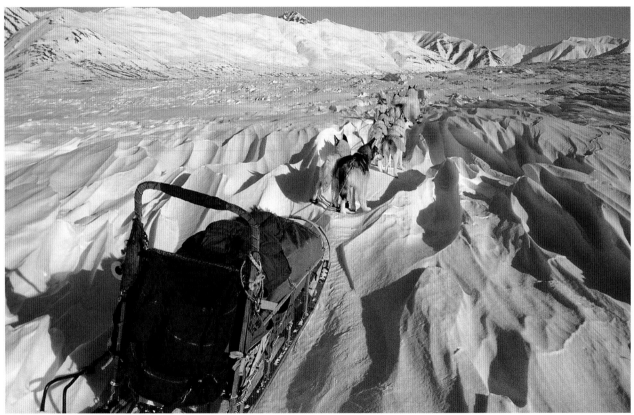

Rough, windblown trail through Rainy Pass, 1979 Iditarod

JON VAN ZYLE

the race. For curious race fans and mushers with a dream, the poster art brought the race trail to life.

In 1978 Jon was asked by the Iditarod Committee to do his second poster, and he agreed to finance another limited edition of 2,500. Like the first year, all 2,500 posters carried his printed name, but only 1,000 were personally autographed and numbered. When Jon discovered an art dealer forging his signature and numbering the posters to sell for the higher price, Jon made the decision that, from there on out, he would personally autograph all his work. What alerted Jon to the forgery was that all the posters had the same number; the dealer had only one of Jon's posters and kept copying that same number!

In 1979 Jon was given the title of Official Iditarod Artist, an honor that he deeply appreciates and still takes very seriously. The original arrangement with the Iditarod Trail Committee was that Jon funded the printing,

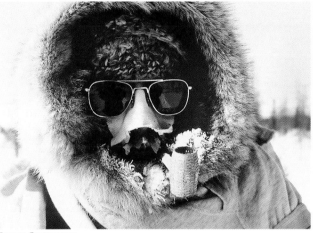

Dennis Corrington

Jon Van Zyle

Above: Near Shaktoolik. So cold I had on every bit of clothing . . . down to the long underwear scarf. Left: Leaders Smokey and Belle during a rest in 1979 Iditarod.

Jon Van Zyle

Above: So this is what First Class is like! Left: Jona at Stampede Race 2000, Willow, Alaska.

Heidi Rhue

chose his own poster subject matter, and retained ownership of the original art. The Iditarod retained all profits from posters the committee sold. Today's arrangement with the Iditarod Trail Committee is basically the same, with the exception that Jon now donates a percentage of all Iditarod poster and print sales to the race.

The popularity of the Iditarod posters and prints is amazing. What started as a one-time, small-scale, good idea of Jon's blossomed into a coveted series for collectors. Not only are the posters and prints collected worldwide, some fans insist on buying the same numbered print each year.

This sled dog race continues to capture the imagination of a high-tech world. Why do people remain so fascinated with an archaic event? Jon and I think the answer is the personal challenge. Our wilderness is vanishing, and today's version of a personal quest is locating a parking place downtown. Computers, videos, and television allow people

access to the entire world from the comfort of their warm, safe homes. However, there is still respect and appreciation—or maybe awe—for the adventurers who dare to dream.

Thankfully, there are still a small number of people who take these challenges: people who celebrate the old connections of man to animal and man to nature. It's the spirit of people like Jon, who dare to make this journey, that inspires the race volunteers and fans to support the Last Great Race.

What amazes me most about my husband is his devotion to his art and his endless creative energy. Even after thirty years of art production, ideas still flow from his heart to his brush. Jon is happiest in the studio, around 3:00 A.M., listening to Joe Cocker or the Dixie Chicks, whistling and dancing along while deeply engrossed in his painting. He may be there in body, but his spirit is somewhere out on the trail.

I hope the personal insights and anecdotes I've been able to draw from Jon will add to your enjoyment of his Iditarod posters and your appreciation of his twenty-five-year affair with the Iditarod.

Left to right: Jon, Anouk, Ambler, and Jona. Jeff Schultz

9

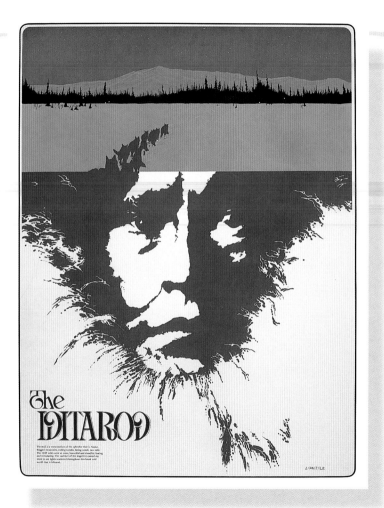

1977

The Iditarod.

The trail is a cross-section of the splendor that is Alaska. Rugged mountains, rolling tundra, biting winds, raw cold. The 1049 miles were at once beautiful and dreadful, boring and stimulating. The cadence of the dogs' feet causes my mind to see lights scattered throughout this bleak cold world that is Iditarod.

18" x 24" 2,500 printed. $5 unsigned. $10 signed.

The original painting for the first Iditarod poster was part of Jon's 1976 one-man show which featured work based on Jon's experiences in his first Iditarod. Once the decision was made to print a poster for the Iditarod, this was Jon's choice: the creative, graphic style captured the essence of the race for him.

The image conveys the hardships of distance racing. We view the weariness, daily wind, and weather on the musher's face. We see the musher, but the top portion of the image becomes the musher's view of his dog team rhythmically moving forward into the night. The quiet drumming of the dogs' feet in the snow, the soft sounds of the dogs' breath, and the song of the runners sighing over the snow invite tired minds to wander. Jon was hallucinating that as each dog's foot touched the snow, it produced a luminescent green light. The light started with his leaders and slowly moved back through the whole team. By the time he reached Galena, the entire team's feet sparked and glowed like live, bare wires brushing together. A memorable night, but only one of the twenty-six memorable nights spent on the trail during his first race.

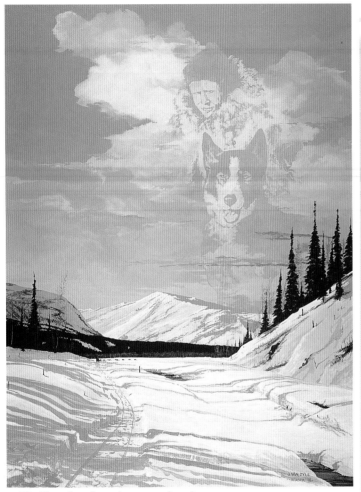

The Iditarod . . . from whence come legends

1978

The Iditarod . . . from whence come legends.

Jon chose a montage format for the '78 and '79 posters. By superimposing various experiences in one visual image, he hoped to relate a more detailed story about the trail.

18" x 24" 2,500 printed. $10 unsigned.
$15 signed and numbered.

This poster features the spirit of one of Alaska's most famous mushers, Leonhard Seppala. Leonhard and his leader Scotty are overlooking the beautiful trail heading towards Puntilla Lake. Seppala, from Norway, was one of the intrepid mushers who participated in the 1925 serum run from Nenana to Nome. The mushers carried life-saving diphtheria antitoxin serum over the Iditarod Trail, which was the old mail route running across the territory. Seppala and his team of Siberian huskies traveled 150 miles from Nome to meet the relay. They received the serum packet, turned around, and raced ninety-one miles back across windswept Norton Sound to Golovin where the packet was passed to a fresh team for the next leg of the relay. For his part in the serum run and his winning record in the early All-Alaska Sweepstake Races, Seppala and his huskies earned well-deserved recognition.

The idea for this painting came from the strong feelings Jon had of being part of Alaska's heritage as he traveled the old routes. He experimented with painting styles and glazing techniques and wanted to capture the spirit and energy of the race in a new manner. Jon didn't realize that with his new glazing style—painting as many as forty or fifty thin layers of color—nothing was completely painted out. He was shocked to see that the printing process picked up the underpainting. If you look carefully at the clouds, you'll see the ghost eyes of the earlier positioning of Seppala and Scotty.

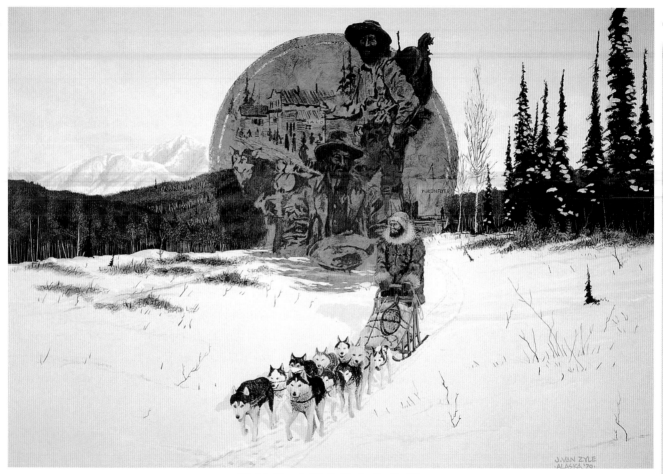

THE IDITAROD
Quietly. Unnoticed. I touched the past. I am.

1979

The Iditarod. Quietly. Unnoticed. I touched the past. I am.

Jon's first Iditarod in 1976 traveled the northern route. In 1977 the trail alternated to the southern route for the first time, and by 1979, Jon felt he had to run it again. He hoped to improve his finish time and see the southern route, but mostly he longed to be out and away on the trail.

In 1975 Jon made the decision to quit his job at Sears and support himself, his wife, and his dogs by painting. He worked hard to build a name and reputation for himself as an artist and, by 1979, was completing over 200 paintings and commissions a year. The rigors of training a dog team for the Iditarod by day and painting by night left Jon exhausted. In support of Jon's race effort, his identical twin brother, Dan, also an artist, flew in from Hawaii to lend a hand. Dan quietly finished the facial details of the musher on this poster late one night while Jon slept undisturbed on his painting table.

Unlike the current well-groomed, well-marked Iditarod trail, early racers spent much of their time breaking trail; mushers averaged about twenty-three days on the trail for the first five years. Spending time on the same routes used by the early goldminers and pioneers invites reflection about their lives. Overwhelmed by the grandeur of nature, and humbled by the determination of those who have preceded you, you come to accept and appreciate all that has brought you to this point, on this trail, this day. Jon used sepia tones to honor the past and a circle-motif around the musher's head to signify completing the circle of the trail's use from past to present. This poster features the Siberian huskies from Jon's 1976 finishing team. Starting with the leaders, the dogs are: Shanda and Keelik, Pikaki and Bashful, Nome and Bobo, Kitten and Smokey, and Tschiggo and Pele.

24" x 18" 2,500 printed. $15 signed. $20 signed and numbered.

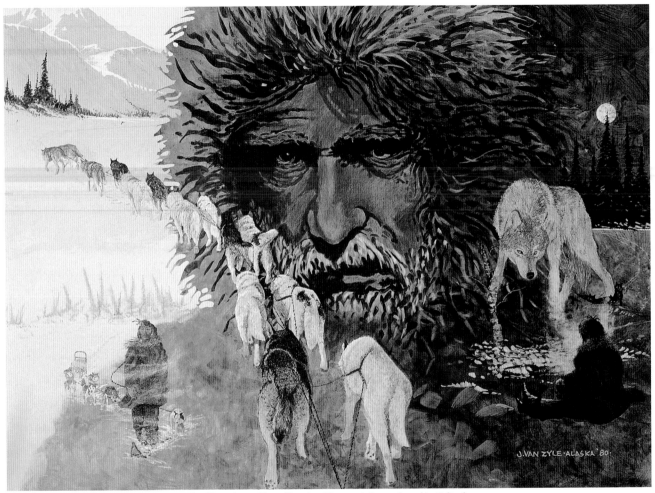

The Iditarod . . . Alone. Together. Teamwork Strengthened in Solitude.

1980

This second sepia-toned montage depicts the fatigue of constant travel. Jon's 1979 race was very windy, and the trails constantly disappeared under drifting snow. The hours and miles of laboriously breaking trail on snowshoes between Ophir and Iditarod helped to blur the days into nights. On the plus side, the many sightings of wolves during the race, and a few special close encounters with them, were wonderful distractions from the wind.

The interdependency and close working relationship between musher and dogs grows in adverse conditions. This poster features Jon's 1979 dog team of Siberian huskies, including, from wheel position forward: Hokulea and Moki, Pikaki and Princess, Kekoa and Seppy, Tschiggo and Strelka, Tuffy and Smokey, Shanda and Bashful, and Kitten and Belle. Many of Jon's dogs were given Hawaiian names which carry warm Hauoli memories
of his island years onto the cold Alaskan trails.

The Iditarod . . . Alone. Together.

Teamwork Strengthened in Solitude. 24" x 18" 2,500 printed. $18 signed. $25 signed and numbered.

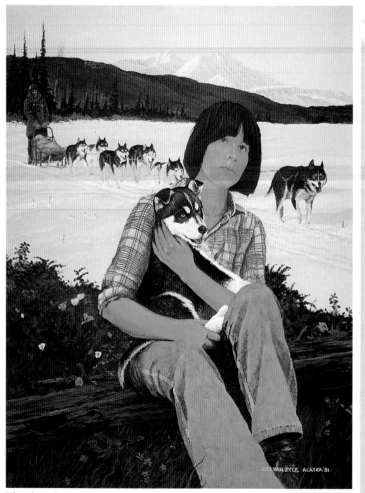

The Iditarod . . . today's dream, tomorrow's trail with yesterday's memories.

1981

The Iditarod . . . today's dream,

tomorrow's trail with yesterday's memories.

18" x 24" 2,500 printed. $20 signed.
$25 signed and numbered.

1981 marks Iditarod's eighth year. The media has started to take notice of the race, and coverage is reaching the lower 48 states and Europe. The mushers who are finishing in the top ten are becoming recognized heroes, and now youngsters picture themselves entering the Last Great Race.

The dream of running Iditarod has led many people, from all walks of life, to head north into a partnership with sled dogs. This year's poster acknowledges the dreams and hopes of a younger generation that will aspire to the trail. Jon's stepdaughter Michelle David, then twelve years old, modeled for the poster along with her puppy Anchor. Although Jon used Michelle as his model, he purposely left the figure's gender ambiguous. Jon hoped that all children could see themselves and their pup leading a team into Nome.

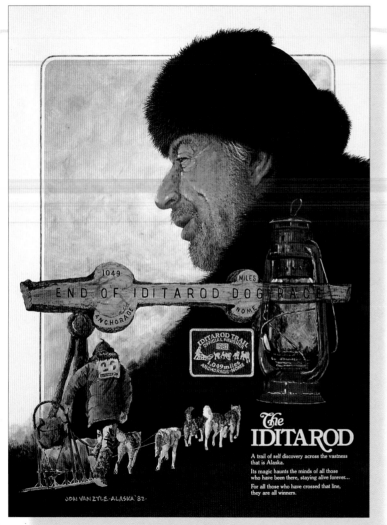

1982

The Iditarod. A trail of self-discovery across the vastness that is Alaska. Its magic haunts the minds of all those who have been there, staying alive forever . . . For all those who have crossed that line, they are all winners.

18" x 24" 2,500 printed. $20 signed. $25 signed and numbered.

The 1982 poster format returns to a graphic art style. Featured is Gene Leonard, the 1979 red lantern recipient. The red lantern is presented to the last team crossing the finish line to symbolically light their way home. Gene and his wife, June, were also longtime race volunteers who checked in teams at Finger Lake; their warm food and encouraging words bolstered the spirits of many teams in the early race years.

Jon tried to highlight the race tangibles of crossing under the famous burled arch in Nome, receiving the finisher's belt buckle, and winning the red lantern. In the early years, the cash rewards were small compared to the pride of completing a trip that most people thought impossible. Jon recognized winning as important, but in an odyssey like the Iditarod, getting to the finish line makes you a winner.

By 1982 Jon's skills and reputation as an artist were on the rise. He regularly traveled Outside for one-man shows, and his work gained popularity in the European market; he could no longer keep up with the demand for over 250 original paintings a year. By reproducing popular paintings in a print format, Jon found he was able to meet gallery demands for his work. Jon also signed with Millpond Press, one of the largest publishing houses at the time.

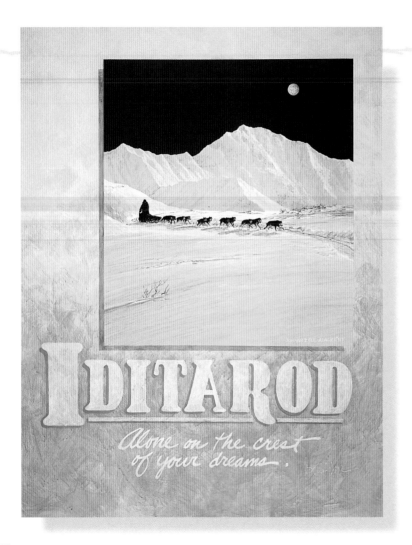

1983

Iditarod. Alone on the crest of your dreams.

By 1983 it was becoming very confusing to the growing number of collectors to have the same poster available either autographed or autographed and numbered. Jon made the decision to stop numbering the posters and start a separate, smaller edition of 500 signed and numbered collectors' prints reproduced on a heavier grade of paper.

New 16" x 20" size. 3,000 printed. $20 signed.

This year's poster marks a transition in the focus of the poster art. The first series of six posters were dedicated to the emotions of running the race. The second series introduces a new size, 16" x 20", and features various people, dogs, and aspects of the race. The subject of the 1983 poster is Rainy Pass, the highest point on the trail with some of the most spectacular scenery. Simply running the Iditarod is a high point in a musher's life: to reach the trail is the culmination of so much work and so many dreams, that actually traveling the trail with your four-legged friends becomes a natural high.

Jon trained his team for a 1983 revival run of the All Alaska Sweepstakes which ran from Nome to Candle and back: 408 miles. He shattered his left knee during this race, and the ensuing surgery and long recovery period tempered his desire for distance racing. He still trains and runs dogs for recreation and winter camping trips, but Jon's gallery and book commitments fill most of his time.

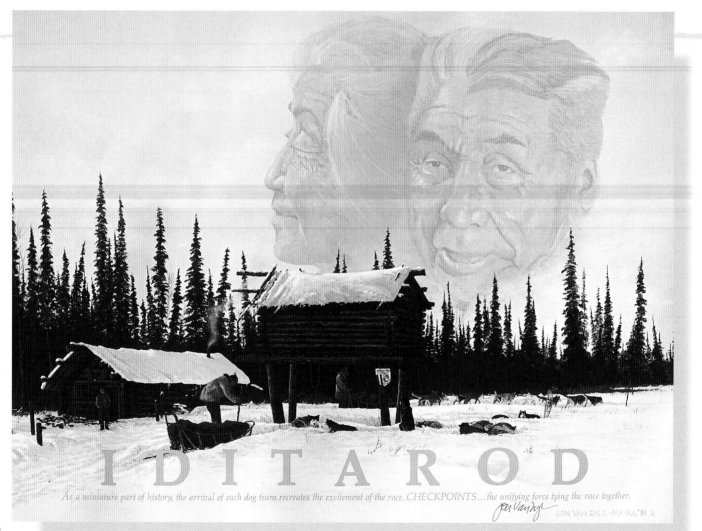

I D I T A R O D

As a miniature part of history, the arrival of each dog team recreates the excitement of the race...CHECKPOINTS...the unifying force tying the race together.

JON VAN ZYLE · ALASKA '81

1984

From 1973 through the 1977 race, the trapping cabin of Miska and Kathrine Deaphone was the Salmon River checkpoint and a favorite rest stop for the mushers. Miska's hospitality and Kathrine's soups and stews offered a warm meal and a safe haven on the trail. Without the high-tech food cookers and other technological advances of today, the race was a longer, slower trip and people were more willing to share meals and trail news as they traveled. This made for a festive feeling of visiting friends; whether they were old friends or newly introduced didn't seem to matter because the coming together for the Iditarod brought a definite sense of community. After Jon met Miska at the checkpoint, the men became close friends, and Jon spent some time living and painting in Miska's village of Nikolai.

Unfortunately, the Bear Creek wildfire of 1977 destroyed Miska's cabin along with a heartbreaking 361,000 acres of adjoining land; only Miska's storage cache remained after the fire. Now called the Farewell Burn, this ninety-three-mile stretch between checkpoints is the longest, and possibly the roughest, run. In years of minimal snowfall, the charred stumps and rough terrain are merciless on sleds and mushers. For many of the older mushers who still race today, passing this area stirs many emotional memories.

Iditarod. As a miniature part of history, the arrival of each dog team recreates the excitement of the race . . . CHECKPOINTS . . . the unifying force tying the race together. 20" x 16" 5,000 printed. $20 signed.

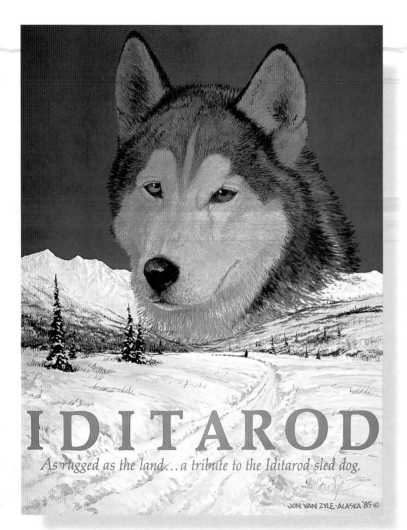

IDITAROD

As rugged as the land...a tribute to the Iditarod sled dog.

JON VAN ZYLE · ALASKA '85 ©

1985

Iditarod. As rugged as the land . . .
a tribute to the Iditarod sled dog.

Although some of Jon's art is of a specific
mountain or river area, much of it is of typical
Alaska terrain. Jon prefers to incorporate
characteristics of several possible locations, so
the viewer can picture their own special "spot."
This seems to work well: at Jon's shows, there
can be ten people in a single day, all referring
to the same image, who are sure they know the
exact place depicted and say, with great
excitement, "I've been there many times and
I didn't think anyone else knew about it."

16" x 20" 5,000 printed. $25 signed.

Bobo, one of Jon's Siberian huskies, is featured on this year's poster. Bobo was what mushers call an honest dog: a dog with a steady dependable work ethic and a friendly upbeat attitude. Bobo wasn't a great leader and didn't perform amazing feats, but he was a hard worker and Jon's special companion for fifteen years. This was the type of human-dog relationship Jon wanted to recognize: dogs that work as a team with the musher to conquer whatever adventure lies ahead. He wanted to pay tribute to the amazing huskies, the northern breed dogs, and the village dogs that make the thousand-mile journey possible. These are the dogs you hope for when whelping a litter of puppies or when you pay more than you should for a dog. These are the dogs that bring tears to Jon's eyes when he fondly remembers them all.

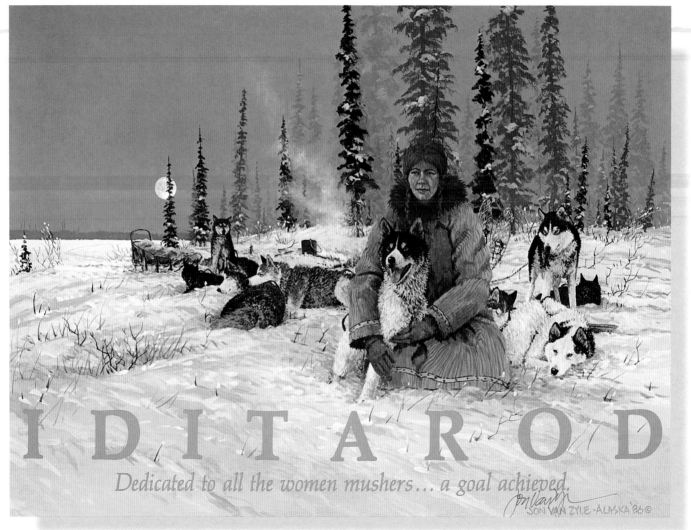

IDITAROD

Dedicated to all the women mushers... a goal achieved.

Jon Van Zyle · Alaska '86 ©

1986

In 1985 Libby Riddles won the Iditarod; suddenly, the race was receiving more publicity than it had in the previous twelve years combined. People were amazed that a demure young woman could race—not only race, but race to win.

Women had been running in the Iditarod since 1974: Mary Shields and Lolly Medley were the first women to complete the race that year. By 1985 Susan Butcher had completed seven Iditarods. She finished in nineteenth place her first year and continually moved up with two ninth-place finishes, two fifth-place finishes, and two second-place finishes. Susan has an unmatched string of successes from 1986 through 1993 that no one has equaled today: four firsts, two seconds, one third, and one fourth.

Jon wanted this poster to honor all the women who follow their dreams into the race. It wasn't meant to depict a specific woman but to recognize women's traits of determination, strength, and skill, as well as their gentle nurturing abilities. Jon's stepdaughter Michelle David and his dogs Kekoa, Tschiggo, and Mosby were the models. The poster must have struck a chord with fans because it sold out rapidly. As a musher living in Ohio those days, struggling to find snow and training trails, this poster fired my determination to head north with my team.

Iditarod. Dedicated to all the women mushers . . . a goal achieved. 20" x 16" 5,000 printed. $25 signed.

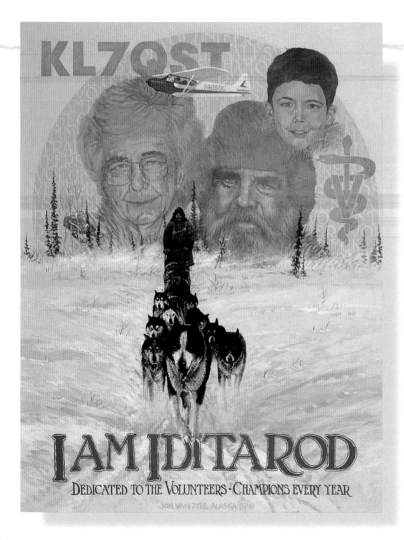

1987

I Am Iditarod.

Dedicated to the volunteers ·

Champions every year.

This poster was a bouquet of thank-yous for the many volunteers; without them there wouldn't be a race. Some people dream of running the race, and others with Iditarod fever dream of working at the race and donating their time. Not only Alaskans volunteer: there are fans from the Lower 48, foreign countries, sponsors, and supportive family members of racing mushers who work behind the scenes. The thought and design for this poster placed a supporting circle of people and activities behind the musher.

16" x 20" 5,000 printed. $25 signed.

Jon's mushing companion and friend Darrell Reynolds was the model for the musher, and Darrell's leader Sundance is in front of his team. Vera Gault, Jon's former mother-in-law, is representative of all the telephone hotline operators, dropped dog caretakers, crowd controllers, timers, checkers, cooks, and clean-up crew volunteers. Jon's stepson, Bobby David, was the model for the musher's patient, and hopefully, understanding family who stands behind the musher's efforts. The snowmachine honors the hardy trailbreakers who pack and mark the one-thousand-plus miles from Anchorage to Nome. The Supercub airplane credits the Iditarod Air Force that flies hundreds of hours and moves thousands of pounds of freight, dogs, and volunteers over inhospitable land in dangerous winter conditions. A large caduceus, the emblem of the medical profession, acknowledges the growing number of veterinarians and vet technicians who monitor the health and safety of the hundreds of hardworking canine athletes involved in the race. Jon salutes ham radio operators, who handled most of the race communications in the early days of the race, with the call letters **KL7 QST**. **KL7** is an Alaska identification number, and **QST** means "anyone respond."

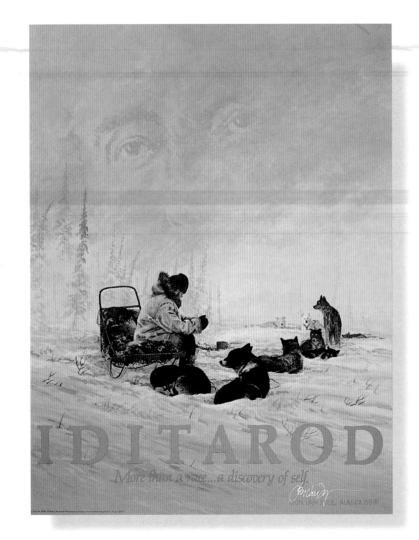

1988

Iditarod.

More than a race . . . a discovery of self.

16" x 20" 5,000 printed. $25 signed.

The theme featured this year is the inner battle against oneself rather than the outward struggle of musher and team against the trail. Unless you have traveled in sub-zero weather by yourself for long distances, you don't realize the energy and determination it requires. The physical challenge of the 1049 miles might not be as difficult as the mental and emotional fears, doubts, and fatigue that must be mastered to complete the race. To challenge and survive the race becomes a discovery of self. Jon says that running the Iditarod completely changed his outlook on life: he felt empowered with the realization that he could do anything he put his mind to.

The Yukon River...
somewhere between Blackburn and
Kaltag... I sensed their presence in the
early morning light long before I saw
them. At first agitated, surprisingly
they soon settled down and became
spectators of our long journey.
An unforgettable feeling overcame
me as we passed beneath them ...
a special memory of my 1979 ...

IDITAROD

Jon Van Zyle · Alaska '89 ©

1989

For the twelfth Iditarod poster, Jon introduced a size change, additional text, and a new series sharing the stories behind some of his most memorable race experiences.

The wolf pack encounter was special for Jon because it was unusual for the cautious canids to openly show themselves. The wolves continued their interest in Jon and his team as they wound their way down the river, which gave Jon the feeling of being accepted into their wilderness. It was as if the wolves knew he wasn't to be feared and recognized Jon and the dogs as fellow travelers moving across the same great land.

The Yukon River . . . somewhere between Blackburn and Kaltag . . . I sensed their presence in the early morning light long before I saw them. At first agitated, surprisingly they soon settled down and became spectators of our long journey. An unforgettable feeling overcame me as we passed beneath them . . . a special memory of my 1979 . . . Iditarod

24" x 18" 5,000 printed. $25 signed.

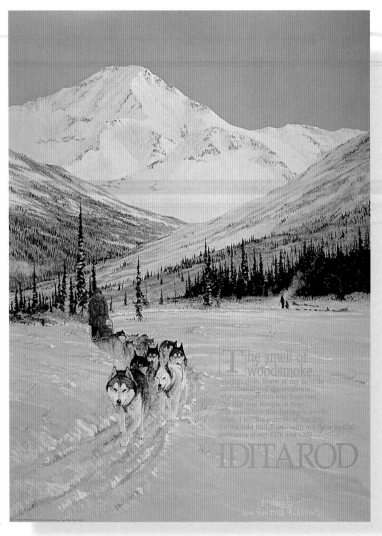

1990

The smell of woodsmoke . . . a warm glow. Some of my favorite memories are of moments when competition was forgotten. The talk was always of dogs, trail conditions and the day's events. When I left the warmth of the fire for the cold trail, I took with me these special memories of my 1976 and 1979 . . . Iditarod.

18" x 24" 5,000 printed. $25 signed.

The act of sharing your daily experiences, whether they be terrible, humorous, or heart-warming, builds camaraderie. Add a cheerful, crackling campfire and you have an easy atmosphere to initiate a conversation or a friendship. Campfires have long offered a source of physical and emotional warmth to man, and along the race trail, they were especially important in the early years. A ready campfire brought you hours closer to food and rest, and the gathering of teams around a shared fire was a chance to exchange trail information and catch a respite from the crusade. You carried the warmth of the encounter with you back out on the trail.

Discussing the changes that have dramatically shortened current race times, Jon came up with quite a list. Surprisingly, straw was the first item. Nowadays, straw is flown to all checkpoints and provided as bedding for the dog teams; its warmth and comfort allow dogs a more restful sleep. In the early days, a musher cut spruce branches—if the trees were available—but usually the dogs slept curled in the snow. Another factor is a better-marked and packed trail. And now there are dog food cookers that eliminate the time-consuming process and problems of fire building, particularly in tundra areas where there's nothing to burn. There is also a better understanding of dogs' and humans' nutritional needs and distance training techniques, and amazing and innovative fabrics now allow mushers to stay warm and dry in lightweight gear. The dogs also benefit with lighter, more comfortable, quick-drying harnesses, booties, and dog coats. All of these improvements make the race faster and safer. There is still fellowship along the trail, but Jon wistfully says it isn't quite the same.

The Dalzell Gorge...
part of the historic Iditarod Trail.
Open water and ice ledges everywhere
... a terrible place.
The snowbridge collapsed, my two leaders
fell through. Throwing the sled over on
its side, I ran to where they
hung motionless in their harnesses,
waiting stoically for me to help them.
A short time later, we continued on our way...
a chilling memory of my 1979...

IDITAROD

JON VAN ZYLE • ALASKA 91 ©

1991

As temperatures drop, the rivers become sluggish and then freeze close to their source. This strangles the flow of water, which, in turn, significantly drops the water level. The surface water freezes in descending, shelf-like layers which can be inches or feet apart depending on the swiftness of freeze-up. Suddenly breaking through the surface ice can land you a heartstopping couple of feet above the icy, rushing water.

The calm trust of Jon's leaders permitted him to carry out the necessary rescue. Later, upon quiet reflection, he realized the seriousness of the situation. At the time, however, the steepness of the gorge, the speed of the dogs, and the lack of a trail left little time to think. You run on instinct and hold tight because it's just another experience in the journey of Iditarod.

The Dalzell Gorge . . . part of the historic Iditarod trail.

Open water and ice ledges everywhere . . . a terrible place.

The snowbridge collapsed, and my two leaders fell through. Throwing

the sled over on its side, I ran to where they hung motionless in their harnesses

waiting stoically for me to help them. A short time later we continued

on our way . . . a chilling memory of my 1979 . . . Iditarod.

24" x 18" 5,000 printed. $30 signed.

The night is cold and crisp...
the only sound is the crackle of the fire. A dog stirs and starts to sing... supper's ready.
The care and tending to my dogs was always one of the simple pleasures of both my 1976 and 1979...

IDITAROD

JON VAN ZYLE · ALASKA '12 ©

1992

The familiar daily routines associated with the care of animals aren't chores for us; we look forward to spending time with our dogs. Once outside there is always the special reward of a vivid sunrise or sunset, eagles soaring overhead, or the antics of the dogs. For Jon it's especially nice to have a reason to get out of the house and away from the telephone or painting. It becomes a chance to stretch, move around, and do something physical for a change. I think the daily routine of dog care becomes a mantra for most mushers: a ritual that brings peace and enlightenment. Whether you're in the midst of your racing agenda or just your regular daily schedule, it becomes a mental health moment we all enjoy.

This poster failed to catch the luminous beauty of the original painting; it reproduced much darker and didn't quite capture the moonlight glow. No matter how careful the printer is, the limitations of the printing process can't match the depth of color and incandescence of Jon's original paintings. The other side of the coin is that while most people can't afford to pay $8,000 to $10,000 for a Van Zyle Iditarod original, $30.00 is reasonable for an image that offers a visual journey down the Iditarod trail.

The night is cold and crisp . . . The only sound is the crackle

of the fire. A dog stirs and starts to sing . . . supper is ready.

The care and tending to my dogs was always one of the

simple pleasures of both my 1976 and 1979 . . . Iditarod. 24" x 18" 5,000 printed. $30 signed.

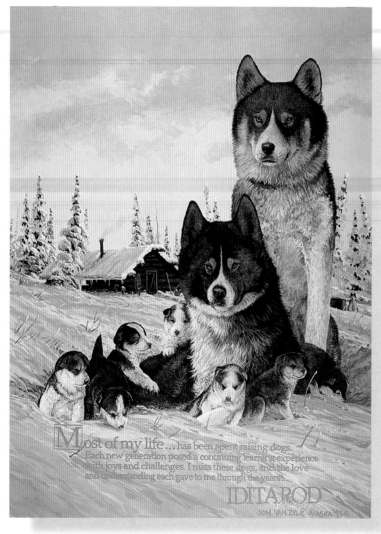

1993

Most of my life . . . has been spent raising dogs. Each new generation posed a continuing learning experience with joys and challenges. I miss these dogs and the love and understanding each gave to me through the years . . . Iditarod

18" x 24" 5,000 printed. $30 signed.

A bad back, bad knees, carpal tunnel problems, and growing art and book commitments slowly moved Jon away from keeping a working sled-dog kennel. He had lost his Iditarod team and was losing their offspring; since he wasn't racing, he wasn't breeding new dog replacements. Jon really missed this aspect of dog involvement, so he painted a litter. This poster proved so popular that the Iditarod used it on many of their collector items including jackets, T-shirts, pins, belt buckles, and coffee mugs.

In case you are wondering if Jon still has any huskies, the answer is "yes." When some couples remarry, they get a ready-made family; when Jon and I married and joined kennels, Jon got a well-trained, well-traveled Siberian husky team. There is a favorite old joke about a musher's Help Wanted ad: "Looking for a female dog handler and kennel manager, experience necessary. Should be strong and caring, love dogs, be a hard worker and have her own truck. Send resume and picture of truck." I had a fast, young dog team and a new dog truck. How could Jon resist?

One of the
most beautiful...
nights of my life was spent
on the long trail to Nome.
The northern lights lit up the
sky at times as bright as day...
as we watched them in awe. The sounds
they made and their dancing bright colors are one of my fondest memories of my 1976 ...

IDITAROD

JON VAN ZYLE · ALASKA 44 ©

44

1994

Jon and his team left the White Mountain checkpoint at about sunset and headed for Nome. Daylight dimmed into darkness and the show began: it was the most incredible all-night lightshow performance Jon had ever seen. While sloshing through Fish Creek, a crescendo of brilliant light accompanied by a swooshing sound stopped the team in their tracks. The shimmering light was bright enough to cast shadows on the snow and held Jon and the dogs transfixed.

Jon swore on a stack of bibles that he would not paint the northern lights because he couldn't capture the ephemeral qualities with paint and brush—all that changed in 1993 when he received an airbrush for Christmas. After much experimentation, he premiered his newfound skills in the 1994 poster. Although the subtleties of Jon's current airbrush skills in rendering northern lights far outshines earlier efforts, it was a start . . . and a very popular poster. Auroras are one of the rewards when enduring Alaska's long dark winters; we are awestruck by the mesmerizing, magical movement of the lighted streamers. Auroras can pulsate and dance merrily across the sky, flutter and billow like sheets on a clothesline, or radiate like a religious experience. One of the largest aurora study centers is the Geophysical Institute of the University of Alaska, Fairbanks. You can visit their website at www.gi.alaska.edu.

One of the most beautiful . . . nights of my life was spent on the long trail to Nome. The northern lights lit up the sky at times as bright as day . . . as we watched them in awe. The sounds they made and their dancing bright colors are one of my fondest memories of my 1976 . . . Iditarod.

24" x 18" 5,000 printed. $30 signed.

Boot'n up...
For every mile of this rigorous trail
mushers care for their teams with respect
and affection... nothing less will do. IDITAROD

©Jon Van Zyle 1995. Published by Alaska Limited Editions, Eagle River, Alaska 99577, Telephone 907-688-3627. OFFICIAL IDITAROD POSTER SERIES. The word Iditarod is the trademark of Iditarod Trail Committee Inc.

JON VAN ZYLE 95

1995

With mushers using over 1,000 dog booties per race these days, boot'n up is a major part of the daily trail routine. The booties are used to protect the dogs' feet from sharp crusty ice or other adverse trail conditions; they also allow a sore foot to be medicated and protected so the wound can heal on the go. In the early days, booties were made of leather or denim. Current hi-tech fabrics like polar fleece and cordura cloth have added comfort and durability, and the addition of elasticized Velcro closures has greatly speeded the process of boot'n up a sixteen-dog Iditarod team.

Jon's friend Stan Smith and his leader Nikki were the models for this poster, which starts a new series of six focusing on integral parts of the race. Jon helped Stan get started in mushing and supported his two Iditarod races. Although Stan no longer maintains a racing kennel, he is considered a real "dog man" having almost mystical abilities in canine communications. Stan advises and assists many well-known mushers as well as Iditarod hopefuls like his son and daughter who have successfully completed several junior Iditarod races.

Jon and I feel it is important to be supportive of novice mushers and the mushing community. Jon has sponsored numerous Iditarod mushers over the years, and we spend time volunteering at races and supporting events with our art. The sport has given us so much over the years that we are happy to be able to give something back.

Boot'n up . . . For every mile of this rigorous trail mushers care for their teams with respect and affection . . . nothing less will do. Iditarod. 20" x 16" 5,000 printed. $30 signed.

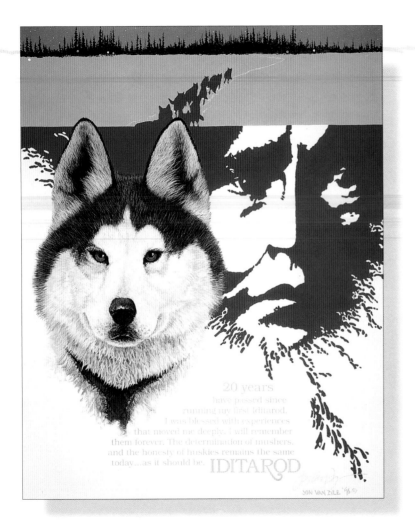

1996

20 years have passed since running my first Iditarod. I was blessed with experiences that moved me deeply. I will remember them forever. The determination of mushers, and the honesty of huskies remains the same today . . . as it should be. Iditarod.

16" x 20" 5,000 printed. $30 signed.

Jon found it hard to believe twenty years had passed since his first Iditarod. Looking over the past nineteen years of poster images, he felt the strongest emotional ties to the first poster and decided to use it again—with the addition of a dog—for the 1996 poster.

1996 also marked the twentieth anniversary of Jon's friendship with Dennis Corrington whom he met on the race trail. 1976 was Dennis's first and only Iditarod, and the men found themselves traveling at about the same pace. Over the many miles, long days, crazy experiences, and practical jokes, they forged a strong bond. They finished the race nine seconds apart, with Dennis receiving the prized red lantern. The strength of their friendship has been their shared race experiences and their deep love for Alaska, its history, and native peoples.

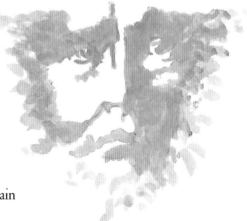

The strength of this poster is the simplicity of the man and dog combination. It is easy to get overwhelmed with the mountain of thoughts, emotions, and images of the race. The basics, however, remain man and dog against nature.

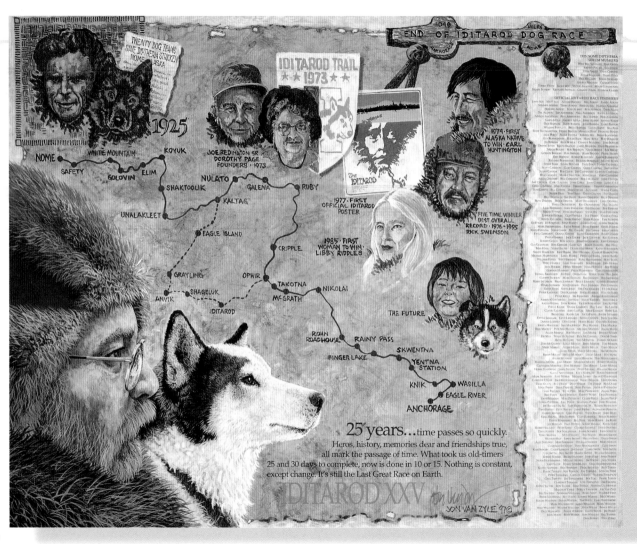

TWENTY DOG TEAMS
SAVE DIPTHERIA STRICKEN
NOME ALASKA

1925

END·OF·IDITAROD·DOG·RACE
ANCHORAGE 1049 MILES NOME

IDITAROD TRAIL
1973

JOE REDINGTON SR
DOROTHY PAGE
FOUNDERS · 1973

1974 · FIRST
ALASKA NATIVE
TO WIN · CARL
HUNTINGTON

1977 · FIRST
OFFICIAL IDITAROD
POSTER

1985 · FIRST
WOMAN TO WIN
LIBBY RIDDLES

FIVE TIME WINNER
BEST OVERALL
RECORD · 1976-1995
RICK SWENSON

THE FUTURE

NOME
WHITE MOUNTAIN
SAFETY
GOLOVIN ELIM
KOYUK
SHAKTOOLIK
NULATO
GALENA
RUBY
KALTAG
UNALAKLEET
EAGLE ISLAND
CRIPPLE
GRAYLING
OPHIR
TAKOTNA
NIKOLAI
SHAGELUK
McGRATH
ANVIK
IDITAROD
ROHN
ROADHOUSE
RAINY PASS
FINGER LAKE
SKWENTNA
YENTNA
STATION
KNIK
WASILLA
EAGLE RIVER
ANCHORAGE

25 years...time passes so quickly.
Heros, history, memories dear and friendships true,
all mark the passage of time. What took us old-timers
25 and 30 days to complete, now is done in 10 or 15. Nothing is constant,
except change. It's still the Last Great Race on Earth.

IDITAROD XXV

JON VAN ZYLE '97©

50

1997

Twenty-five years . . . time passes so quickly. Heroes, history, memories dear and friendships true, all mark the passage of time. What took us old timers 25 and 30 days to complete, now is done in 10 or 15 days. Nothing is constant except change. It's still the Last Great Race on Earth. Iditarod XXV.

In 1972 the Alaska legislature designated dog mushing as the official state sport. In 1973 thirty-four dog teams took off from Anchorage and headed toward Nome in the first Iditarod Trail Sled Dog Race. To mark the twenty-fifth anniversary of the Last Great Race, Jon decided to use a time line along the trail to highlight some of the important people and occasions in race history.

The time line starts with racing legend Leonhard Seppala and his leader Togo, who helped relay the life-saving antitoxin serum to Nome during the 1925 diphtheria epidemic. 1973 features Joe Redington Sr. and Dorothy Page, who are considered the father and mother of the Iditarod race for their efforts in creating and organizing the event. If spaced had permitted, Jon would have included Tom Johnson and Leo Huyck, who were instrumental in the first years, and Howard

20" x 16" 2,500 printed. $30 signed.

Farley and Leo Rasmussen, who organized the Nome end of the race from trail to trophies. The time line continues with 1974: Carl Huntington was the first native musher to win both the Iditarod and the 1973 Fur Rendezvous Open World Championship Sprint. It's an accomplishment no one else has equaled since.

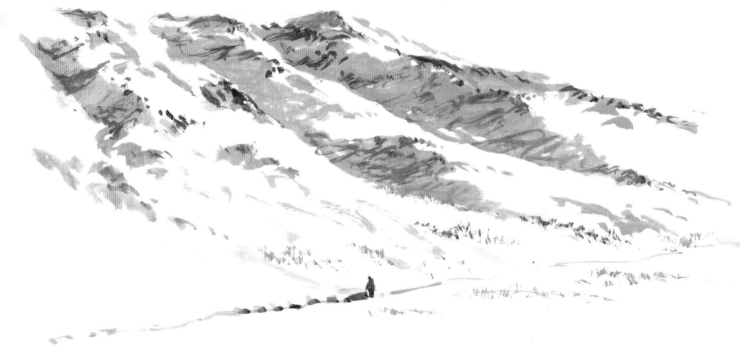

The year 1977 commemorates Jon's first Iditarod poster becoming part of the race and Iditarod's first race merchandise. In 1985 women make their presence known as Libby Riddles becomes the first woman to win the Iditarod.

Rick Swenson definitely has a spot for holding the best overall race record of five Iditarod wins from 1976 to 1995, an as-yet-unmatched feat. Robin Phillips, daughter of Walt and Gail Phillips, longtime Iditarod race supporters, was the model for the future musher.

Jon includes Nome's famous burled arch, which was carved by race finisher Red Fox Olson. When Olson finished the thousand-mile race in 1974, the end was marked by a line of Kool-Aid sprinkled in the snow and two paper plates on sticks. Feeling the racers deserved more, he created the impressive arch for the 1975 race. The arch collapsed after the last mushers finished the 1999 race: the end of an era. Woodworker Bob Kuiper came to the rescue and created a new arch for the 2000 race. By combining fifty wood burls, he produced an impressive and welcoming sight for weary mushers.

Lastly, the names of the twenty mushers from the 1925 serum run, and the names of every musher who has completed the Iditarod up to 1996, make up the right margin of the poster.

Flying high on
different planes...
The logistical framework of
the last Great Race® is held together
by the volunteer Iditarod Air Force.
The mushers thank them for their
dependable skills which provide a
greater margin of safety for
themselves and their dogs.

IDITAROD *Jon Van Zyle*

1998

This poster draws attention to the volunteers of the Iditarod Air Force and the different perspectives of the trail: from the air and on the ground. The area featured is reminiscent of the terrain near Rhon Roadhouse, Finger Lake, or the Skwentna areas.

The pilots have the advantage of height and a great overview of large expanses of wilderness. As they rapidly cover ground, they spot the problem moose, open leads, and oncoming storms that will surprise the unsuspecting mushers on the ground. The mushers feel that it isn't a destination they want to reach but the "high" of the entire experience. Enlightenment comes with quietly gliding through the vast white winterscape, encountering wildlife and danger, and sampling Alaska with all their senses.

To represent the Iditarod Air Force, Jon featured a Cessna 185 aircraft known as a northern workhorse. An average of twenty-eight small airplanes fly more than 1,200 hours and use an estimated 20,000 gallons of aviation fuel to move freight, people, and dropped dogs along the race trail. Some pilots become so entranced by the Iditarod trail that they also run the race. Don Bowers, Bert Hanson, and Bruce and Diana Moroney—to name a few—have experienced both planes.

Flying high on different planes . . . The logistical framework of the Last Great Race is held together by the volunteer Iditarod Air Force. The mushers thank them for their dependable skills which provide a greater margin of safety for themselves and their dogs. Iditarod.

20" x 16" 2,500 printed. $30 signed.

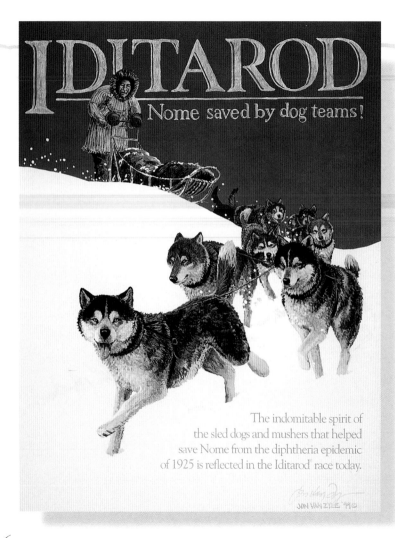

IDITAROD

Nome saved by dog teams!

The indomitable spirit of
the sled dogs and mushers that helped
save Nome from the diphtheria epidemic
of 1925 is reflected in the Iditarod race today.

JON VAN ZYLE '90

1999

Iditarod. Nome saved by dog teams!
The indomitable spirit of the sled dogs
and mushers that helped save Nome
from the diphtheria epidemic of 1925 is
reflected in the Iditarod race today.

From 1973 to 1979, a two-minute period of
silence was observed before the start of each
Iditarod race to honor the memory of legendary
musher Leonhard Seppala and the 1925 serum
run. The best known dog heroes of the serum
run are Balto and Togo, and both of them left
Alaska after the serum run.

16" x 20" 1,500 printed. $30 signed.

In 1927 caring Clevelanders rescued Balto and the team that ran the last leg of the serum run. The team was initially sold to movie producer Sol Lesser, who made a short movie and sold them to a "dime-a-look" museum in Los Angeles where they were mistreated. The city of Cleveland purchased the team from the museum and transported them to Ohio to live out their lives with dignity at the Cleveland Zoo. After Balto's death in 1933, his remains were preserved, and he is still a part of the permanent collection of the Cleveland Museum of Natural History.

Togo and the team that ran the longest leg of the relay toured the lower 48 states with Seppala in 1927. In Poland Spring, Maine, Seppala gave fourteen-year-old Togo to wealthy musher Elizabeth M. Ricker. Upon his death in 1929, Togo's body was preserved and given to the Peabody Museum at Yale. In 1964 the Shelbourne Museum in Vermont acquired Togo's mount, and schoolchildren eventually petted away much of his hair. Mushers rediscovered Togo in 1983 and shipped him back to Alaska. Refitted with new ears and tail, Togo now resides at the Iditarod Trail Headquarters Museum in Wasilla. At the end of 1998, I was organizing an exhibit and programs for the Anchorage Museum of History and Art; the exhibit featured Balto and Togo together again after 73 years. Before moving to Alaska, I had been the assistant curator of the Balto exhibit at the Cleveland Museum and was pleased to have the opportunity to work on the exhibit in Anchorage.

Jon was surrounded by serum run information. Coupled with the January 1999 passing of Edger Nollner, the last surviving serum run musher, Jon decided to dedicate this poster to the spirit and history of the race and chose a graphic art style reminiscent of the 1920s and '30s. The poster doesn't depict a specific musher or dogs because they were all heroes.

IDITAROD 2000

...a good dogteam will take you anywhere!

JON VAN ZYLE 2000©

2000

With the approach of the year 2000, Jon spent weeks thinking about ideas. He wanted the poster to be special and "millenniumish" without straying too far from the musher-dog relationship of Iditarod.

While brainstorming late one night, I made the comment that a good dog team will take you anywhere you want to go; that concept hasn't changed from the earliest days of mushing to the present time, and I assume it will remain the same into the future. Jon's eyes twinkled and he said, "That's it!" as he reached for the ever-present scrap of paper and pencil. He quickly sketched as he talked: He could see a dog team mushing into the future . . . a cosmic dog team streaking through space, blazing a trail into unknown territory . . . it would definitely be something different.

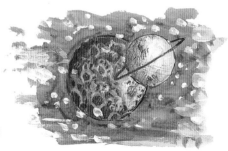

After weeks of celestial research and painting, we viewed the finished artwork. I thought one element was missing: I goaded Jon into giving the musher a space helmet as mandatory trail equipment for the millennium.

This design was used for a 2000 Iditarod T-shirt, and the bright, glowing colors proved popular. Nevertheless, Jon wasn't sure how his devoted poster collectors would respond to the drastic change in color scheme. After careful consideration, he decided to print a smaller edition . . . it sold out in six months.

Iditarod 2000 . . . a good dogteam will take you anywhere! 20" x 16" 1,000 printed. $30 signed.

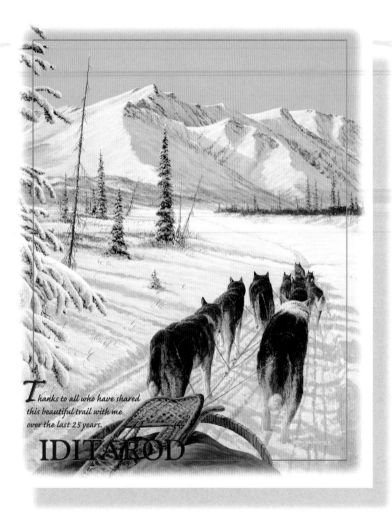

Thanks to all who have shared
this beautiful trail with me
over the last 25 years.

IDITAROD

2001

*Thanks to all who have shared
this beautiful trail with me over
the last 25 years. Iditarod.*

*For his twenty-fifth anniversary poster,
Jon has chosen a perfect sunny March day
and given you, the viewer, an honest dog
team moving steadily through Alaska's
wilderness on a trail you can travel forever.*

16" x 20" 1,500 edition size. $30 signed.

In 1976 as Jon approached the solid burled arch signaling the finish in Nome, he didn't want the adventure to be over. He wished he could continue the trip on to Teller, then Wales, then who knows where. Wrapped in a cocoon of memories, after a misty silence, Jon quietly repeated the thought that he never wanted it to end. He is thankful for the popularity of the posters and, most importantly, to the people who purchase them, for allowing him to continue the journey.

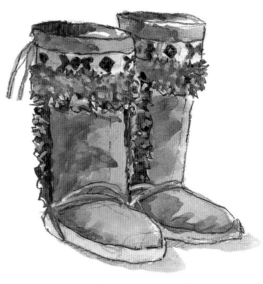

Far from being the end of Jon's Iditarod poster trail, this twenty-fifth poster is just another checkpoint in the journey. It's an occasion to reflect on Jon's progress as well as an opportunity to assemble the whole "team" of posters to date. For Iditarod poster collectors, Van Zyle art fans, or those who simply relish Alaskana, we hope you continue on down the trail with Jon Van Zyle.

Merchandise

Currently, the Iditarod Trail Committee markets Jon's posters and other Iditarod commemorative items through their product catalogs, retail shops, and Internet website. Jon's artwork has been used for a wide variety of collectible merchandise over the past twenty-five years, and it produces an impressive amount of dependable revenue for the race.

To contact the Iditarod Trail Committee, call 1-800-545-MUSH (6874) or www.iditarod.com

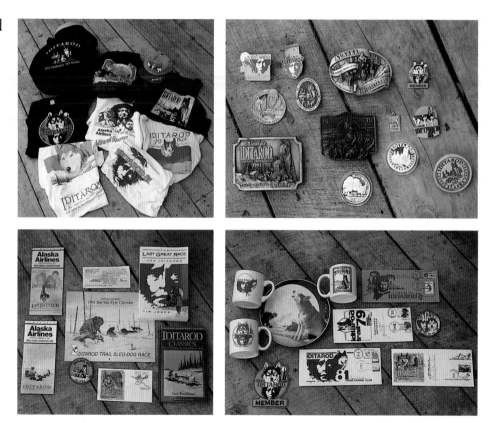

Galleries

The original Iditarod poster and print paintings are about twenty-five percent larger than the reproductions and are exhibited and sold in galleries in the United States and Europe. More extensive marketing of Jon's art is handled by Alaska Limited Editions. They sell his Iditarod work and his other numerous art prints and posters: Alaska Limited Editions, P.O. Box 746, Eagle River, AK 99577. (907) 688-3627. Listed below is a sampling of the galleries that carry his art.

Artique, Ltd.
Anchorage, Alaska

Secondary Art
Anchorage, Alaska

Picture This
Eagle River, Alaska

New Horizons Gallery
Fairbanks, Alaska

The Art Shop
Homer, Alaska

Rainsong Gallery
Juneau, Alaska

Scanlons Gallery
Ketchikan, Alaska

Frames & Things
Soldotna, Alaska

Town Square Gallery
Wasilla, Alaska

First Street Frame
Turlock, California

The Frame Shop
Yuba City, California

Deer Ridge Gallery
Fort Collins, Colorado

Central Gallery
St. Petersburg, Florida

Tundra Gallery
Mackinaw City, Michigan

Ark II
Flemington, New Jersey

Gallery One
Mentor, Ohio

Art Cache
East Burke, Vermont

Nordkyn Outfitters
Graham, Washington

Art Concepts
Tacoma, Washington

Landmarks Gallery
Milwaukee, Wisconsin

Klondike Shop
Stafa, Switzerland

Sources

A Fan's Guide to the Iditarod, Mary H. Hood

Father of the Iditarod: The Joe Redington Story, Lew Freedman

Iditarod: An Historic Trail. Brochure produced by U.S. Department of Interior, Bureau of Land Management, in cooperation with Heritage Conservation and Recreation Service.

Iditarod Classics, Lew Freedman

Iditarod Country, Tricia Brown and Jeff Schultz

Real Alaskans, Lew Freedman

JON VAN ZYLE ONLINE

Original paintings and sketches, limited edition prints, posters, and other books illustrated by Jon Van Zyle may be ordered from our website, www.EpicenterPress.com.

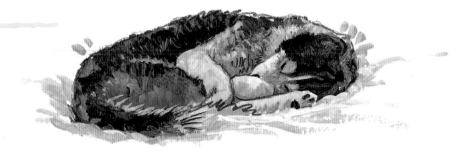

May the wind be at your back,

may your partner and dogs be steadfast and true,

and may you find "that perfect trail"

you can travel forever.